Crispy Ink Muse

Written & Photographed by

Laura DeGrave

King's Slough Boat Ramp @ Ocoee, Tennessee

(Cover photograph: The Rock Garden @ Calhoun, Georgia)

Copyright © Laura DeGrave 2024
All rights reserved.
ISBN: 978-1-304-51623-7

Big Bend Recreation Area @ Reliance, Tennessee

Dreaming Season

Wistful dreams under fluttering emeralds gilt bright

Fanciful lovers bathe among seafoam drifts white

Cicada song fortes within falling solar tresses

Tropical winds dance to folly ocean's caresses

Wave riders delight upon surf tossing curl

Kites take flight creating a mosaic whirl

Flowers shouting independently across heaven's evening shade

The country rejoices 56 ink freedom made

Crisp watermelon ever so ruby red sweet

Summer picnic treasure shared between our feet

Campfires, bonfires, and sparkling candlelight heart fires

Breath passing quickly embracing passion's storm transpires

Butterflies flit about the breeze seeking nectar

Fields of swaying grass exhibiting nature's splendor

A quiet respite holding an unwritten book

Heavy eyes closing visions for next season's hook

Hooper Bald Trailhead @ Robbinsville, North Carolina

Summer Blues

My water park is wash the car
I'm up at dawn to mow the lawn
All the chore money goes in the jar
Pop rustles newspaper and gives a yawn
Momma hollers, "Go on!"

My takeout is the trash can
Fun in the sun weeding the garden
All this excitement I can't stand
Hold my breath and count to ten
Momma hollers, "Go on!"

My vacation travel is the mailbox
Snapping beans by the potful
Cracking corn off their stalks
Chicken pox are plain awful
Momma hollers, "Go on!"

My summertime is a waste
Stirring paint and coating fence boards
The blues sounding more taste
Pop humming some radio chords
Momma hollers, "Soup's on!"

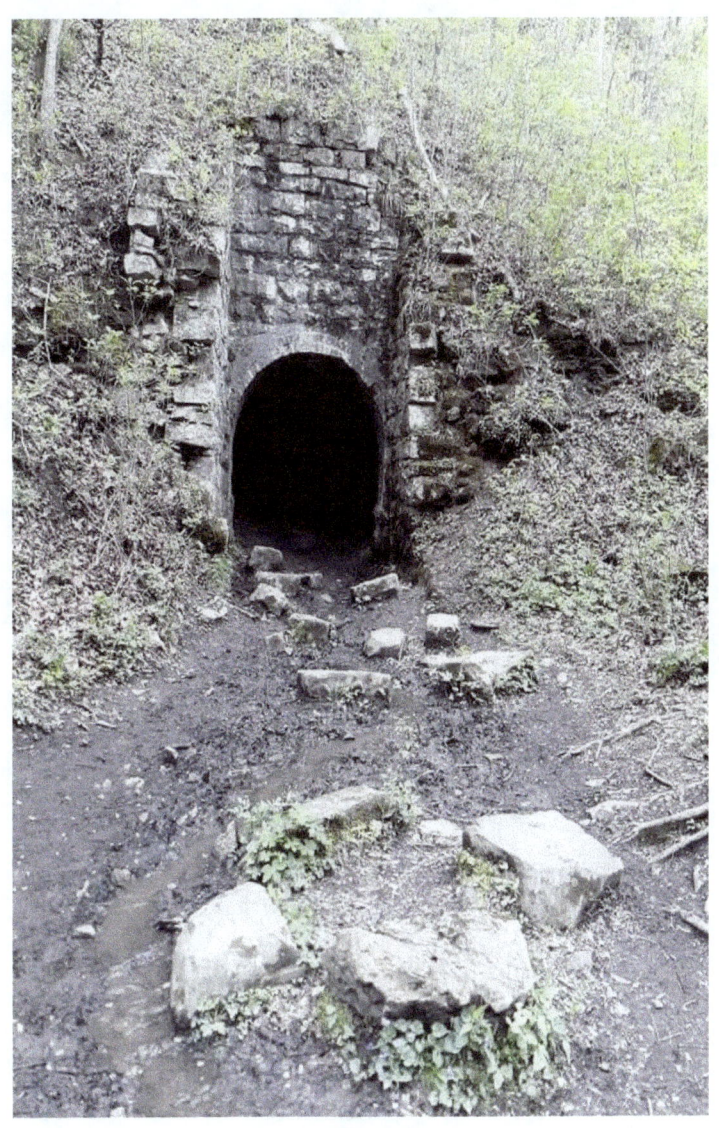

Laurel Snow State Natural Area @ Dayton, Tennessee

Read The Bones

We traveled the arduous path to Howling Cave.

Our plight of famine made me a knave.

Wind blew through us screaming wide hunger's crave.

My furs caught lift from the draft's breath.

Chilled deep within we heard bones crack death.

Small and gnarly the figure sat before us.

Her sparse hair veiled the breeze in thrust.

She laid a clawed hand upon her bust.

"Madame, my friend and I, came for guidance."

"Sit by the fire, I know all circumstance."

The oracle began to scribe on two plastrons.

How sacred turtles must be, spawn for divinations.

Markings to gods unheard, scarred smooth virgin bonds.

"I require metal payment," her rheumy voice implored.

Our only possessions were Greek bronze in sword.

She plunged my kopis in the gaping flames.

The weapon burned blue and green, revealing aims.

My companion's offering, she kept aside fire claims.

"The blade is cold, he will grow fat."

She glared at me, "Bones speak, gnat."

The extracted glowing metal singed and scorched bone.

Each prod scored a notch, preparing to atone.

A fissure appeared, popping made ready the crone.

She studied the crack as I awaited destiny.

Oracle froze and the plastron snapped forth binary.

"Madame, what is it that you had seen?"

Sweat beaded above her brow and wrinkled between.

"The place where you wish had never been."

"What place do you speak of in fear?"

"Your friend may leave, I honor his volunteer."

Powerhouse Boat Ramp @ Reliance, Tennessee

White Train

"This way, miss," a man's voice ushered amongst the quiet.

He mirrored the train; hat, jacket, and gloves donned white.

Velvet crushed underfoot, along nonchalant polite stare met passerby.

Pintsch's lanterns sheen rippled silken curtains, cream plumes gone awry.

He opened a private compartment and directed me in placement.

Printed news splayed over a gentleman's face, covered snoring vent.

Golden seating greeted comfort and alleviation toward the journey's end.

Trolley dispersed Queen cakes with tea to many a patron.

My companion didn't wake from the rattle of china clanking.

Gently we swayed in unison, the rambling wheels cranking.

The headline on the paper read, 'Charles River Lovers Dead'.

Lambert buggy found off Harvard Bridge, washed ashore from riverbed.

"Seat check, Miss, have your ticket?" asked the conductor.

"I bought her ticket," the gentleman sat up, my protector.

I felt chilled, noticing our clothes soaked, my heart drop.

My love happily said, "We follow the railway bones- nonstop."

The Point @ Emerald Isles, North Carolina

Scrimshander

Leave your crossbones in ink, marks on salty eyes.
Cast off all landlubbers, far winds lift seagull cries.
Longitude and latitude care not... for here be dragons.
Saint Elmo's fire tests the warmth in your flagons.
Mermaid songs ache sweeter than a whale pod serenade.
Jolly tars crossing Neptune's boiling sea, a doldrum trade.
The Bosun's shanty, "Zounds, by the winds, no whistling!"
"Trim the sheets, watch the cat, whitecaps coupling mizzling!"
Devilfish baiting us to visit Davy Jones' Locker cellmates.
A sailor's unfound beliefs deepens sea faring finer traits.
Keep a weather eye on the North star cove.
Secure the wren's feather inside your pocket and clove.

Dance a jig, me hearties, Prospero's wildling tempest blows.
Our dear Penelopes suffer the weird sisters unforeseeable woes.
Honey lather the grog to fasten the bitter ends.
May we never meet Cleito's isle where Hercules defends.
Saints preserve us and the mast be shod proper.
Lovely oaken lady, calm these tantrum flares into whisper.
Aubergine shawls adorn the heavens, embracing Helios' chariot ride.
We breathe the brine apropos gamboling the great divide.

Occoee Dam #2 TVA @ Polk County, Tennessee

Melancholy Love

Liquid grief
Pressing miniature ponds
Kindness smiles brief
Snapping kinship bonds
Pale face crushed

Beyond reconcile
Melancholy love
Treacherous mountain mile
Heavens song above
Hardened lips hushed

Dawn permeates
Halting waterfalls
Opening hazy gates
Lush nature calls
Tender soul brushed

Crisp air
Cleansing intake
Hearts laid bare
Logic's tragic mistake
Sweet melody hushed

Hiawassee Outfitters @ Reliance, Tennessee

Country Air

To be great-
never hate.
To love-
don't shove.
To heal-
selectively reveal.
To apologize-
energize.
Make a mistake-
grab a rake.
Open mind-
being kind.
Feeling gassy-
here's a paci.
For healthy heart-
please fart.
Be beautiful-
with a toot full.

Parent's house @ Calhoun, Georgia

Cheerful Girl

Spin, spin, spin!
Twirl, twirl, twirl!
Aren't you a bright
And cheerful girl?
Turn the key,
Play for me,
Pointed toe symphony!
Moody ring,
Bit of sterling,
Plastic pearl string,
Length of ribbon,
Thread on bobbin,
Shiny lost button,
Four leaf clover,
Picture of rover,
Lip balm lover,
Sun bleached seashell,
Silver jingle bell,
Boyfriend heart mail...
Spin, spin, spin!
Twirl, twirl, twirl!
Aren't you a bright
And cheerful girl?

E.G. Fisher Public Library @ Athens, Tennessee

Lost in Tale

Cold wooden slats
Breathless morning
Train click clacks
Motorists roaring
Full harvest moon
Street lamps mourning
Jovial voices tune
Cool breeze scorning
Ghost cat trails
Vibrant leaves adjourning
Aged bone wail
Tears storing
Lost in tale
Anguish boring
Searching the grail
Timeless loring
Vacant bench
Soul for lorning
Heart strings pinch
Memories adjourning

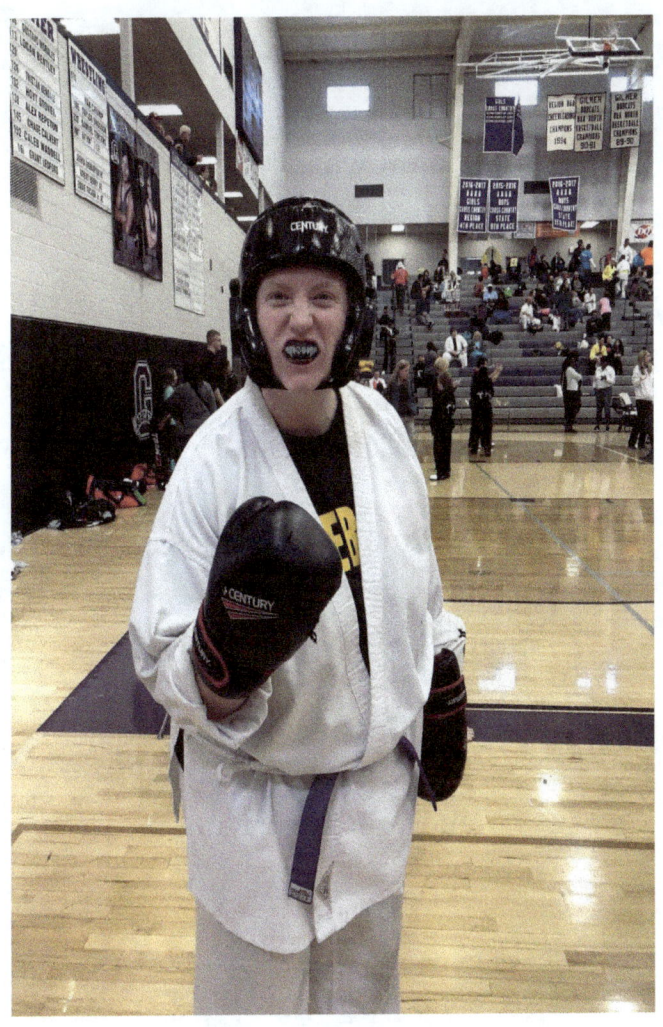

Ben Kiker's 45th Annual Tri State
Tournament @ Ellijay, Georgia
(photo by friend, Christie Mathis)

Fight Song Cadence

I don't know what I've been told

I found karate in my soul

Front kick
Side kick
Back and round

Black belts knock me to the ground

Wipe the blood up off the floor

Get up now

And fight some more

1-2
3-4
1-2-3-4
1-2
3-4

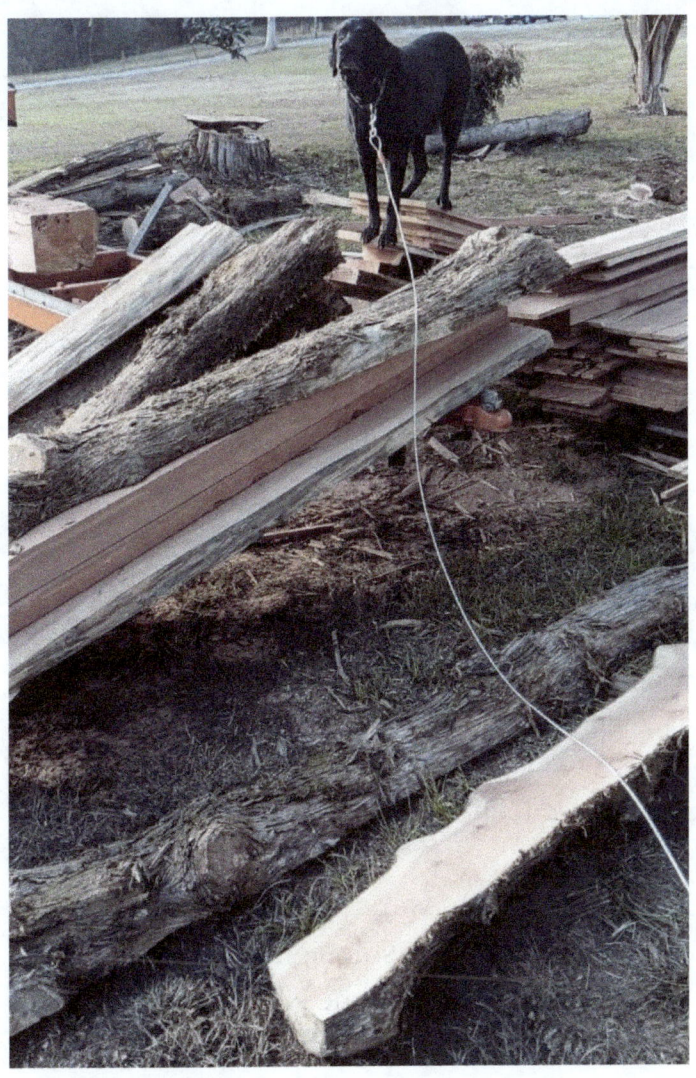

Sawmill Man's Tree Job @ Tennessee
(photo by husband, Eric DeGrave)

Sawmill Man

Puffs of life escaped parted lips
Raised to greet Sun's stretched fingertips
Trade tools hitched in-line back
Saw, winch, rope, petrol, and tack
A call sent for winter cord
Fresh rings hewn, live edged hoard
Raised the maul high, struck true
Cracked years to wedges, tempo cue
Another bell rung for rustic planks
Future decor or home building blanks
Timber cleaved on serrated teeth band
Wooden snow fluttered mounds, forest sand
Full trusted partner paid in sticks
Lover of roads, shotgun rode, no tricks
Four-legged foreman with most friendly handshake
Duck to water, Jake's play break
Dimmed light star signaled road home
Mind over em dashes followed, roamed
Savory wafts enticed flavored interlude dance
The wife's open-hearted awaited for stance
"I'm home, love. For you, see?"
"'Bout Time! Wash up! Love you, really!"

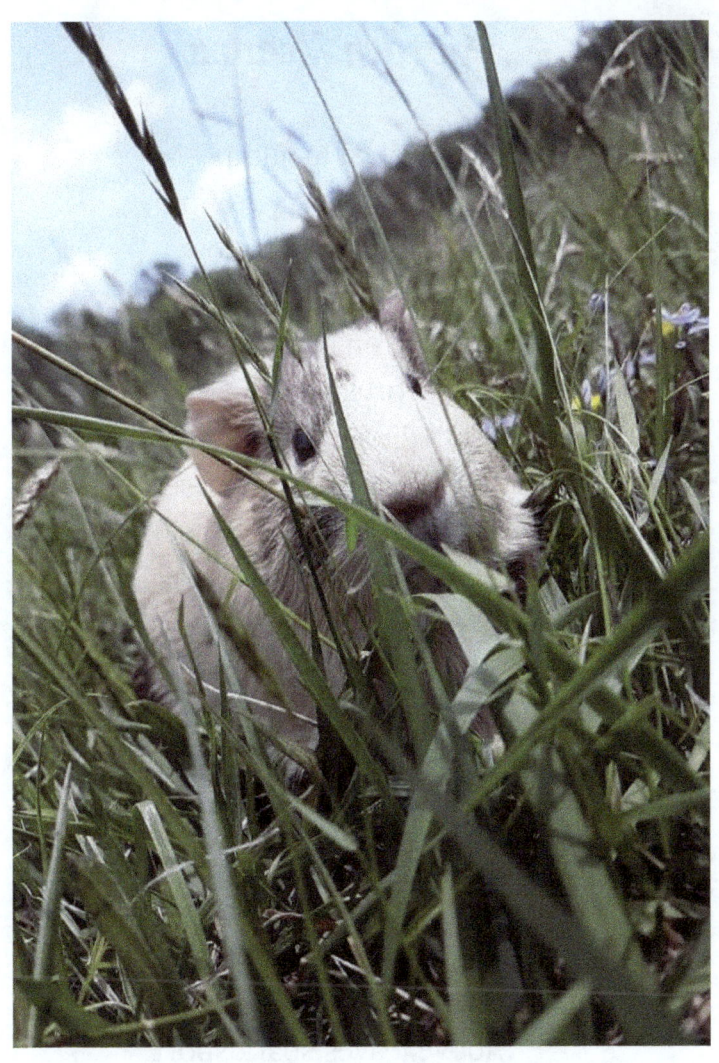

Sprinkles Adventure Chickamauga Battlefield
@ Fort Oglethorpe, Georgia

Garden Meadow

Hop, skip, jump
Pops the furry rump
In a garden meadow
A peculiar little fellow
Crunching on dandelion salad
Feather brush spring ballad
Blossom dressing aroma sweet
Mushroom circle fairy seat
Chandelier dew jewel silk
Forbidden treasure fly ilk
Saffron stripe dusty butlers
Pocket cargo pollen burs
Lattice encompass spiral tendrils
Deeper the root tills
Rich earthen foundation provides
Wriggling shoestrings there hides
Chamomile tea smoothes honey
Delectable sips measure ye
Shade tree view comfort
Above leaves spark sport
Combat which leaves support
A cardinal heralds court
Surprise catch Ides downpour
Dash chorus garden door

About The Author

United Karate Studios Banquet 2020 @ Chatsworth, Georgia
(photo by friend, Kelli Rogers)

Laura is an aspiring writer who loves stories. She lives in Riceville, Tennessee with her husband, Eric and their three fur babies; Jake (water dog), along with Sprinkles and Turnip (guinea piggies). They all enjoy little adventures, riding roads, picnics, chilling at home with movies. You can find her on Facebook @ 'Scribbles by Laura DeGrave' and Instagram @ 'JakeWaterDog'.

Dedication
Eric DeGrave, my husband
Kelli Rogers & Christie Mathis
To ALL Who Support Me

Bonus Scenes

'Jake The Water Dog'

Young children's picture book created from personal photographs. Join Jake and his best friend, Bear on their hunt for big water.

'Rustle in the Leaves'

21 poems chapbook created from a 21 day poetry contest by Bookleaf publishing. 21 shots to the moon and one may land as your star.

'Popcorn Krunchers Shorts with Bite'

8 various short fiction tales made to entertain in time for popcorn. Keep it Salty!

Up & Coming

'12 For 12 - GAME ON! One Year Book Challenge'

A reading journal to promote literacy and its benefits. Works well for cognitive skills, annotators, book clubs, bookstagrammers, and sketch artists fan art.

'12 For 12 - Kids! One Year Book Challenge'

A reading journal to promote literacy and its benefits. Works well for focus, recall, and creativity. Made to encourage kids to see reading as FUN.

www.ingramcontent.com/pod-product-compliance
Lightning Source LLC
Chambersburg PA
CBHW071445170526
45158CB00005BA/1841